Nikolai Gol

Maria Haltunen

THE HERMITAGE CATS

TREASURES FROM THE STATE HERMITAGE MUSEUM, ST PETERSBURG

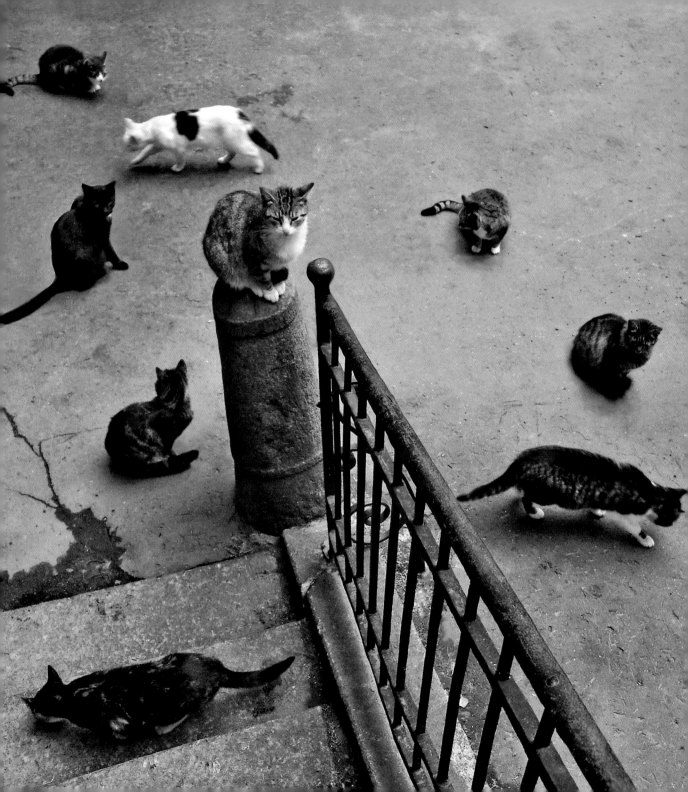

CONTENTS

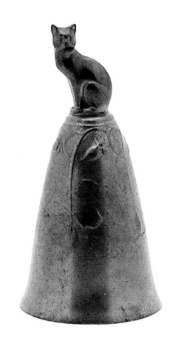

Our cats love the Hermitage – even more than some humans, and we greatly appreciate their role as "ushers" inviting people to Russia's greatest museum in St. Petersburg.

Recently I have been asked a lot more questions about our cats than about our Rembrandts, and that's not a bad thing for a change. The cats call forth kind feelings in those who work in the Hermitage and in those who visit it. This stimulates a love of animals, an understanding that animals need to be cared for and protected.

The cats have become a very important part of our museum life and one of the most persistent Hermitage legends. A great many true stories and tall tales are told about them, but where there are cats truth and fiction always mingle.

In the whole world there is only one other place where cats have it so good, and that's the British Museum. There they even have special little houses built for them, something we are also thinking of. I hope that at some time in the future today's young readers and visitors will help us to build comfortable and attractive houses for cats, suitable for Rastrelli's architectural master-piece that houses the Hermitage collections.

Mikhail Piotrovsky
Director of the State Hermitage

A great many people think that the Hermitage is only a **museum**.

Some people know that it is also a serious **research centre**, where works of art are studied, restored and preserved. And only for a very small number, a chosen few, the Hermitage is **home**.

It is to these – the Hermitage cats – that the authors dedicate their book.

Two kinds of cats can be seen in the Hermitage. The real ones, who occupy the Hermitage basements, have been in state service, attached to the museum, for more than 260 years now. The other kind of cats are part of the museum exhibits, the best loved specimens in the Hermitage "menagerie". They are looking at us out of display cases and canvases by the great masters.

Cats in art and real-life cats – these two sorts of felines are the subjects of this lavishly illustrated book. It provides an interesting insight into the long history of interaction between humans and cats.

►
Cat on a Stove
Christopher Unterberger
Copy of a fresco in the Raphael Loggias
in the Vatican. 1778–88. Detail

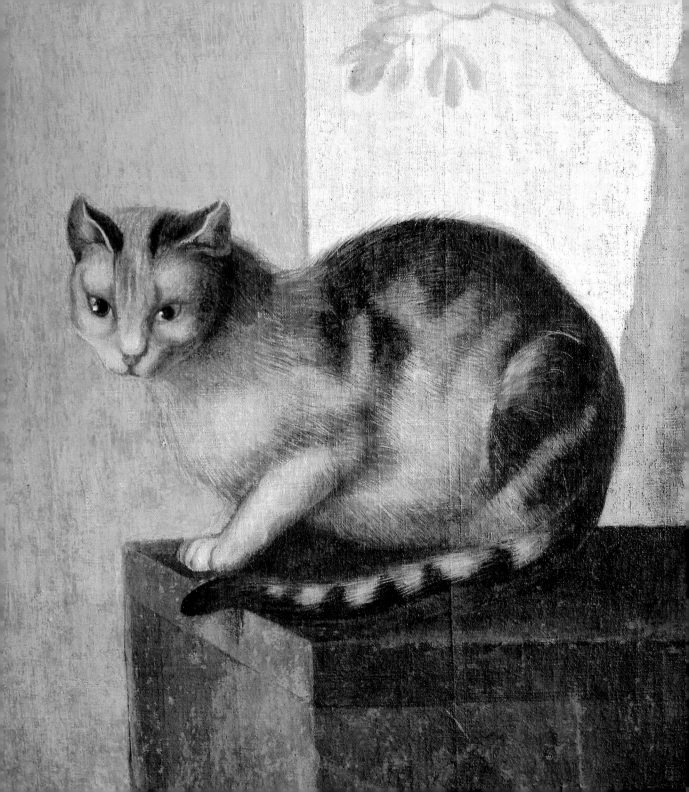

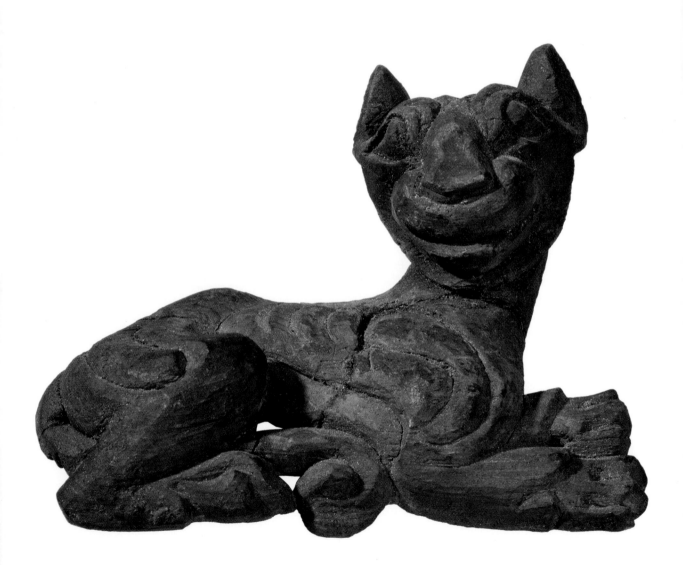

ANCIENT EGYPT: from guard to god

The cat came into contact with humanity a long time ago. When people learnt how to produce a sizable harvest and began to store up grain, they encountered a serious problem. Rodents of all kinds, especially rats and mice, got into the habit of raiding their stores. The early farmers needed a reliable guard – smallish but spry, with vision that was as good by night as by day, and feared by vermin. That was why people first thought of domesticating cats.

That took place in Ancient Egypt in the time before recorded history – even before the Egyptians began building their famous pyramids.

The first domesticated cat was the wild Nubian. It used to be thought that it was tamed over 5,000 years ago. But recently archaeologists working on the island of Cyprus discovered an ancient burial which along with human remains contained those of a domestic cat – after all, it is not very likely that a wild animal would be buried next to a human. Now scientists claim to have found the world's oldest known pet cat. This Cypriot cat is 9,500 years old.

Since that time domestic cats diligently served humanity by exterminating greedy little thieves. Back then, preserving the grain harvest amounted to saving people's lives.

◄

Figurine of a cat
Pazyryk burial mound, Altai mountains

Late 5th – early 4th centuries B.C.

And so cats came to occupy a special place in people's lives. They even began to be given the same status as the gods. At the time of the Old Kingdom (3rd millennium B.C.), the ancient Egyptians referred to their supreme god, the sun deity Ra, as "the Great Cat". Sometimes he was depicted in the guise of a large ginger tom defeating the master of darkness, the underworld serpent Apophis (Apep), in the same way that the sun daily triumphs over night.

In Ancient Egypt the cat was the sacred animal of the goddess Bastet, the protectress of women and the domestic hearth, the goddess of love, fertility and joy. Indeed, there can scarcely be an animal more gentle, graceful and affectionate than the cat. And there are few that can compare to it for cheerful disposition, for the way cats can delight and amuse their owners.

The goddess had a whole city – Bubastis – dedicated to her. The ancient Greek historian Herodotus, who visited the place, wrote that at the annual festivities held there in honour of Bastet "more grape wine is drunk than over the rest of the year. According to the locals, up to 70,000 people of both sexes gather here, not counting the children."

One of the main sights of Bubastis was the temple of the goddess Bastet. A large number of cats lived in the temple precincts and were cared for by specially appointed priests. The city also had a cemetery exclusively for cats.

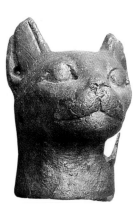

Top of a staff shaped as a cat's head
Ancient Egypt. 11th–8th centuries B.C.

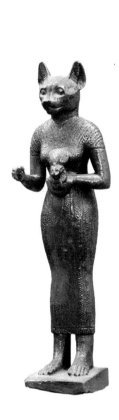

The goddess Bastet was often represented as a standing figure with the body of a woman and the head of a cat. Sometimes she held a ceremonial sistrum (a kind of wire-rattle used in Isis worship) in one hand and an aegis (shield) in the other. Here, in the Hermitage exhibit, the shield is embellished with the head of a lioness. This may be an allusion to the close kinship between Bastet and the "superior cat" – the terrible lioness-headed Sekhmet (or Sakhmet), the goddess of war and baking heat.

**Bronze figurine of the goddess Bastet
with a cat's head**
Ancient Egypt. 1st millennium B.C.

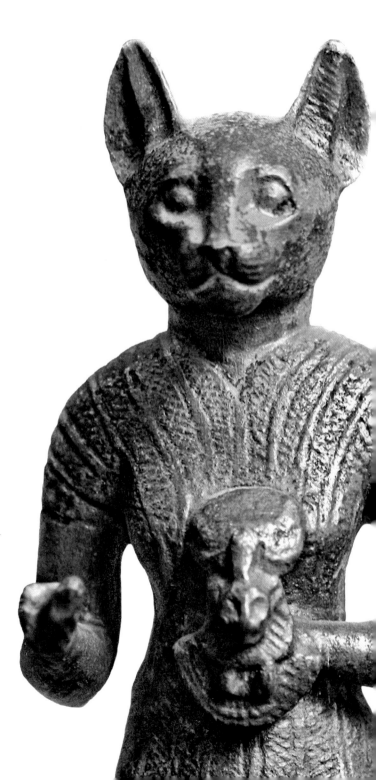

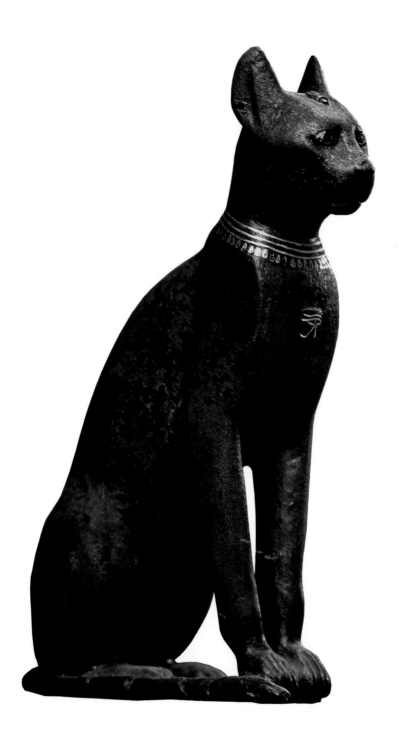
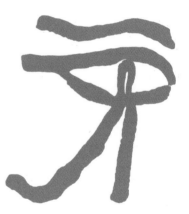

Bronze statuette of a cat
Ancient Egypt. 7th–6th centuries B.C.

When a cat died, its owners shaved off their eyebrows as a token of mourning. The dead cat was brought to the temple at Bubastis, where it was embalmed, wrapped in linen bandages and buried in a special sacred repository. In order that the poor creature should not starve on the long journey to the afterlife, embalmed mice were put in with it.

In Ancient Egypt the killing of a cat was considered a very serious crime, punishable by death, whereas a person who killed a slave had only to pay his master the slave's worth. In other words, a cat's life was rated incomparably higher than a human's.

On one occasion the Egyptians' religious sentiments were exploited by Cambyses II of Persia. When he drew up to fight the army of Pharaoh Psamtik III, the cunning Persian king ordered his warriors to tie cats to their shields. Afraid of unintentionally injuring the sacred animals, the Egyptians refused to give battle.

The Roman historian Diodorus Siculus reported that someone once killed a cat in Bubastis. "A crowd gathered at the home of the guilty man [and] representatives of the authorities were unable to protect that man from vengeance, although he had killed the animal by accident."

Diodorus, a contemporary of Caesar and Augustus, described this incident with some sympathy. In Ancient Rome, where cats were imported from Egypt by way of Greece, they were treated with tremendous respect (except the black ones).

The cat was the sacred animal of the goddess Bastet.
On her chest she wears an amulet in the form of an eye −
the wejat *eye, a sign of the protection of the supreme god Ra*
to whom she is related.

ANCIENT GREECE: out of a jug onto an amphora

In Egypt, it was forbidden by law to ship the sacred animals overseas. But the resourceful Greeks managed to hide cats in jugs, putting them to sleep with a potion of poppies, and secretly smuggled them across the sea to Greece. If a smuggler was caught, he was executed and the cats returned to their homeland.

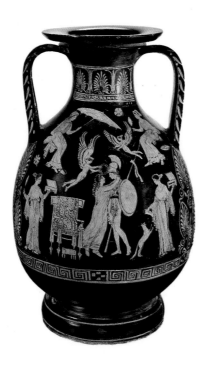

Here we see a rich Greek lady playing with a cat. Why a rich lady? Because in the fourth century B.C., when this amphora was made, very few Greek homes could afford such a luxury as its own cat (just as very few people nowadays can keep a monkey or a koala). By the start of the Christian era, however, cats had become a common sight in people's homes. They were now entrusted with a serious task: protecting the home from mice, work previously performed by domesticated ferrets.

Red-figure pelike vase
Apulia, Southern Italy. 4th century B.C.

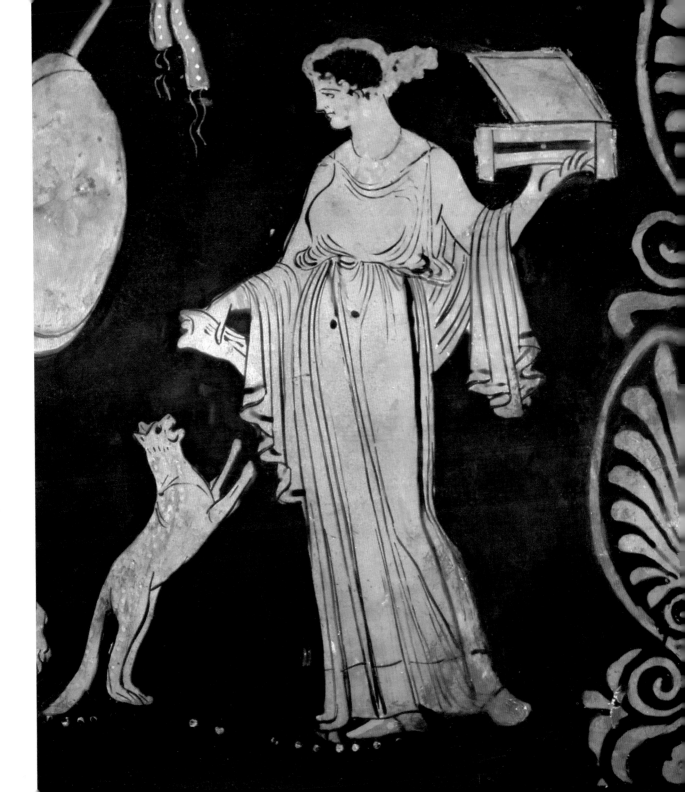

EUROPE: from enemies to pampered pets

Travelling by land and water, the feline race spread quite rapidly around the world. And almost everywhere cats were welcomed and respected.

For the wealthy burghers and aristocrats of Europe, domestic cats became beloved and pampered pets. It is said that even the head of the Roman Catholic Church, Pope Gregory I, was so fond of his kitten that he carried it with him all the time in the sleeve of his loose cassock and did not part with it even when preaching. It was Gregory who gave permission for cats to be kept at monasteries and convents.

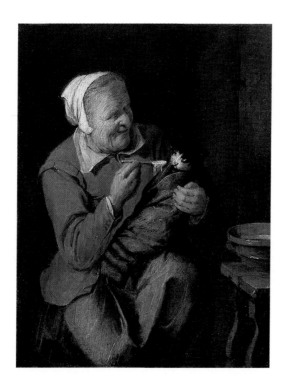

Peasant Woman with a Cat
David Rychaert III
Flanders. 1640s

►
Children with a Bird and a Cat
Eglon Hendrik van der Neer
Holland. 1680s. Detail

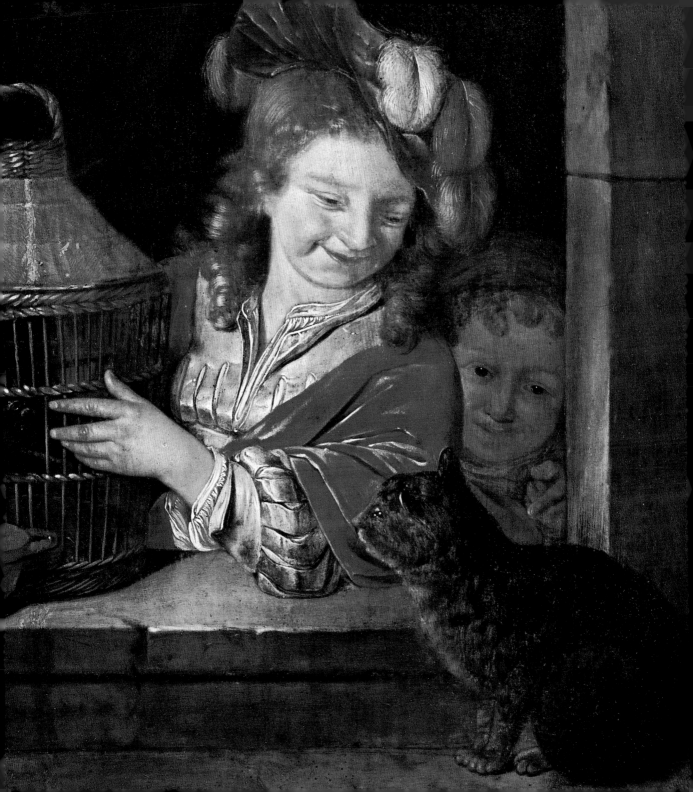

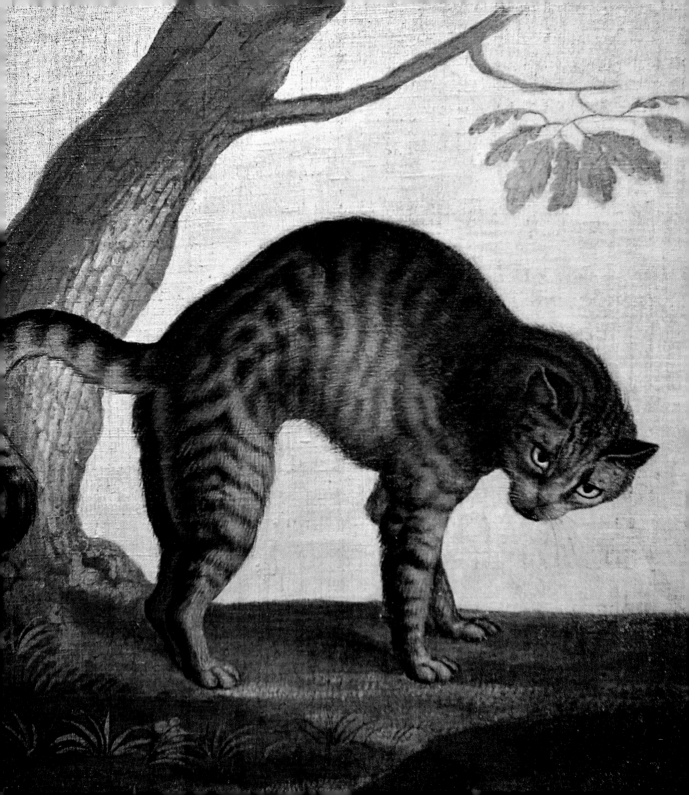

In the Middle Ages unhappy times began for the cats of Europe. Their inexplicable ability to see at night caused the superstitious to associate cats with witchcraft. Cats' eyes, moreover, shine in the dark, and their pupils change shape and size depending on the lighting – that was considered a sign of untrustworthiness. On top of everything, cats were mysteriously capable of finding their way home, no matter how far they strayed. So people began to suspect the feline race of being in league with the dark forces.

Terrible things were said about cats everywhere. Witches, for example, rode to their sabbath astride cats, and could themselves change into cats. Even the devil would at times take on the appearance of a cat.

The 1586 treatise *De daemonomania magorum* contains a story of witches who used to assume the form of cats and gather at night in a deserted castle. Once some travellers stopped there for the night and the cat-witches pounced upon them in the dark. One of the party was killed, several more wounded, but in the end they managed to slay many of their attackers, who, to their horror, resumed their female appearance at the moment of death.

It was said that cats as witches' "familiars" could help their mistresses to gain possession of anyone else's property. And many people believed that – after all, who knows what's on a cat's mind?

◄

Cat
Christopher Unterberger
Copy of a fresco in the Raphael Loggias
in the Vatican. 1778–88. Detail

Looking at this sinister creature with fluorescent eyes,
it's not hard to believe that cats are somehow linked with
the dark forces.
In any event, that was what people thought at the time
when Raphael decorated the loggias in the Vatican Palace
(1517–19).

Cats are capable of getting into what seem to us the most secret places and in the blink of an eye making away with what was not meant for them at all.

Black cats were particularly unfortunate in the past. Pope Gregory IX, who came to rule the Vatican several centuries after his cat-loving namesake Gregory I, officially confirmed the connection between black cats, witchcraft and the devil. He went so far as to say from the pulpit: "The breath of a cat is pestilence... if a cat drinks water and a teardrop falls from its eye, the spring will be poisoned."

The cats had every reason to shed tears. The sixteenth and seventeenth centuries saw the terrible period of witch trials. Cats, along with their owners, were accused of conferring with the devil, and thousands of them were burnt at the stake. In Flanders they were thrown alive from castle walls.

Two Witches with a Cat
Jacob de Gheyn the Younger
Holland. About 1610

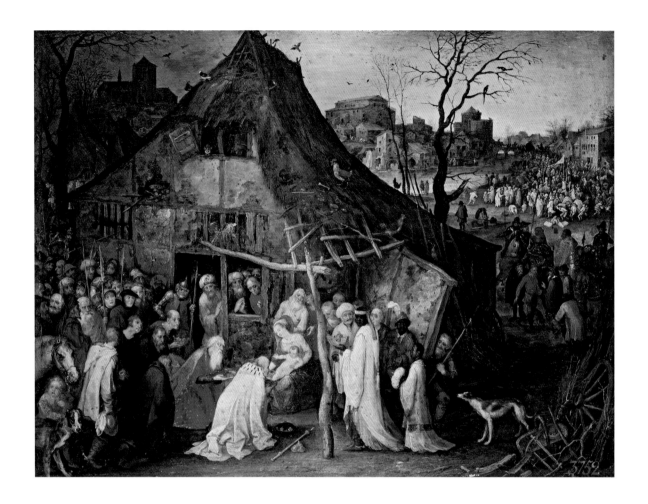

Artists customarily resorted to symbolic language when they needed to reveal to the viewer the thoughts and secret intentions of some personage or hint at how events were going to develop.

The Adoration of the Magi
Jan Bruegel the Elder (Velvet Bruegel)
Flanders. Between 1598 and 1600

When Christ was born in Bethlehem, he was visited by wise men or magi from the East bearing gifts, and also by a group of shepherds with their animals – sheep, cows and dogs. All God's creatures rejoiced at the birth of the Saviour. But the artist did not include the cat among their number. It observes what is taking place from a detached position in the attic. Remember that in Bruegel's time cats were believed to be servants of the devil.

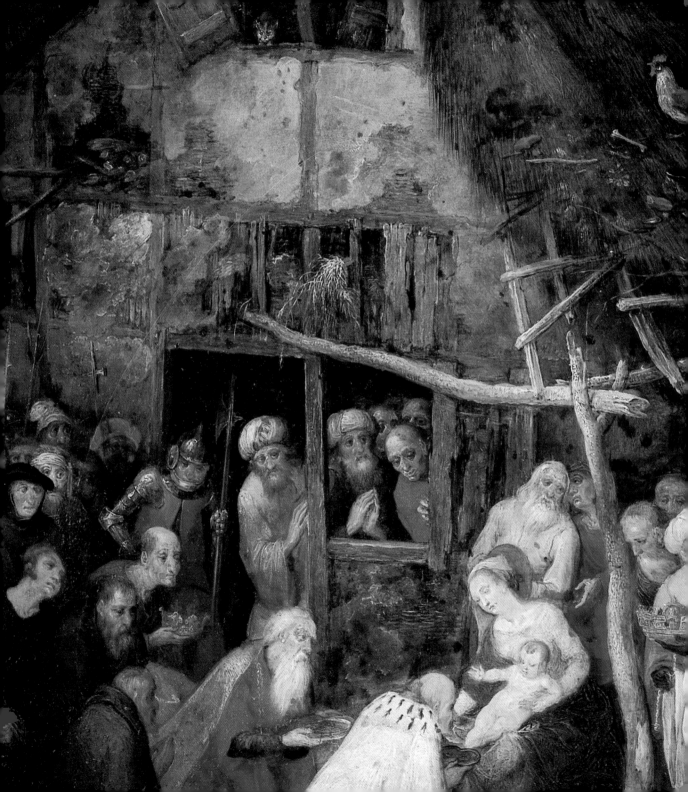

The famous Venetian artist Tintoretto here depicted more than just the birth of John the Baptist. Using symbolic language he also showed what the infant's fate would be. In the foreground we see a young cockerel being attacked by a cat. Just as the cockerel was the herald of the sun, St. John was regarded as the forerunner (or messenger) of Christ. By depicting the attack of the dark forces in the form of a cat, the artist indicated how perilous his mission was to be.

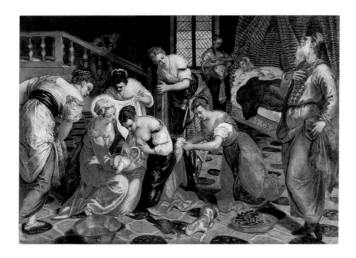

The Nativity of St. John the Baptist
Tintoretto (Jacopo Robusti)
Italy. 1553–54

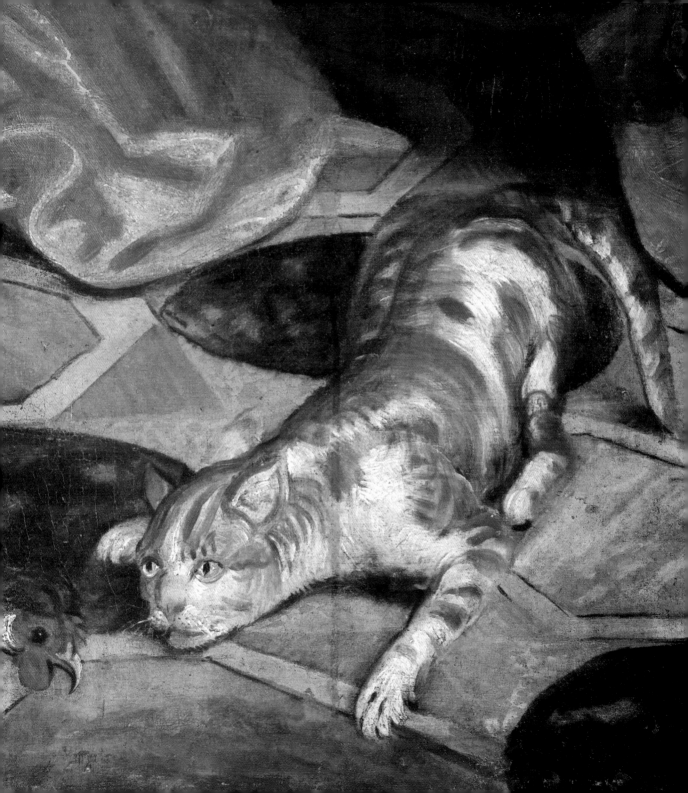

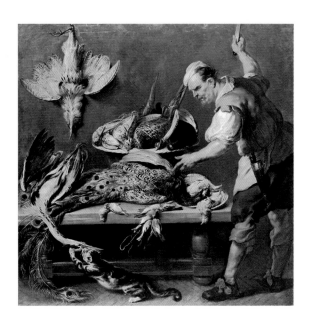

Cook at a Game-laden Table
Frans Snyders
Flanders. Between 1634 and 1637

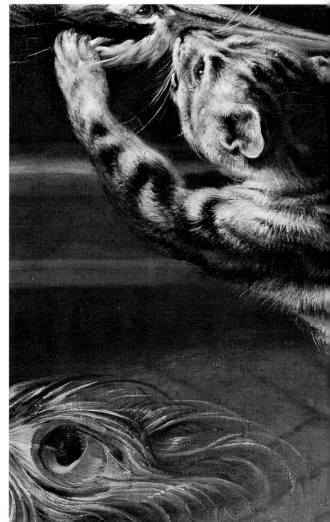

In the Hermitage picture gallery cats are probably most often seen in the paintings of the seventeenth-century Flemish artist Frans Snyders.

If you take a close look at his canvases, in almost every one you can glimpse a feline in some out-of-the-way corner.

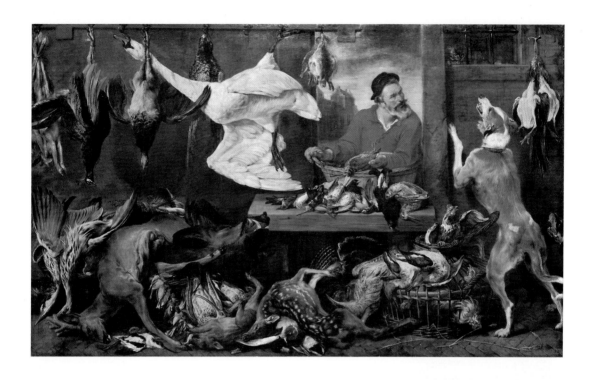

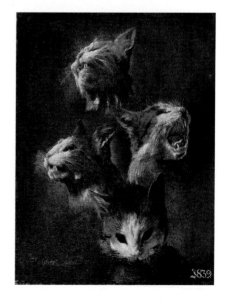

▲

Game Stall
Frans Snyders
Flanders. Between 1618 and 1621

Sketches of a cat's head
Frans Snyders
Flanders. 1609

It is thought that here the artist depicted four different emotional states of a cat as reflected in its "facial expressions" – from peaceful to aggressive.

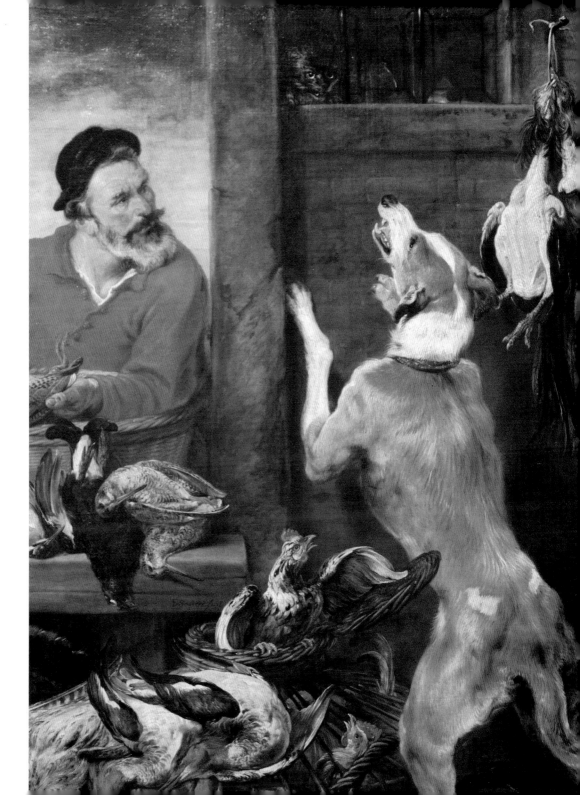

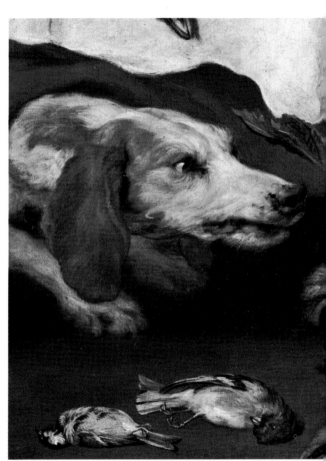

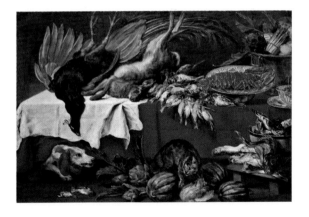

In the works of Flemish artists cats are usually active, even aggressive. Their eyes are fiery, their fur on end − real predators. It is immediately plain that a beast like this won't retreat even in the face of its arch enemy, the dog.

Still Life with Dead Game and a Lobster
Pauwel de Vos
Flanders. 1640s–50s

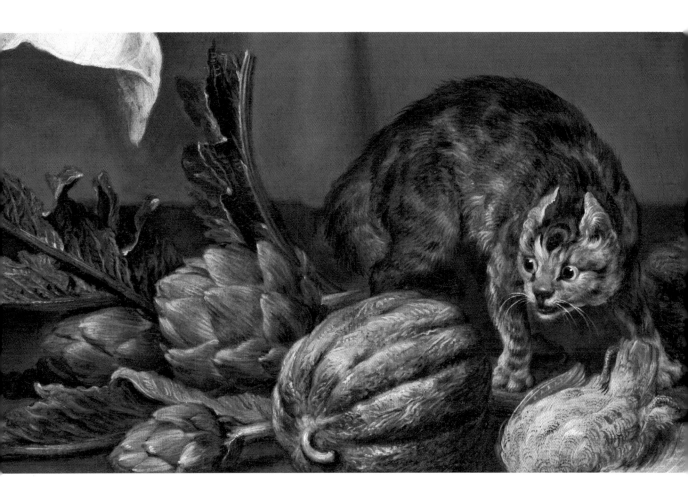

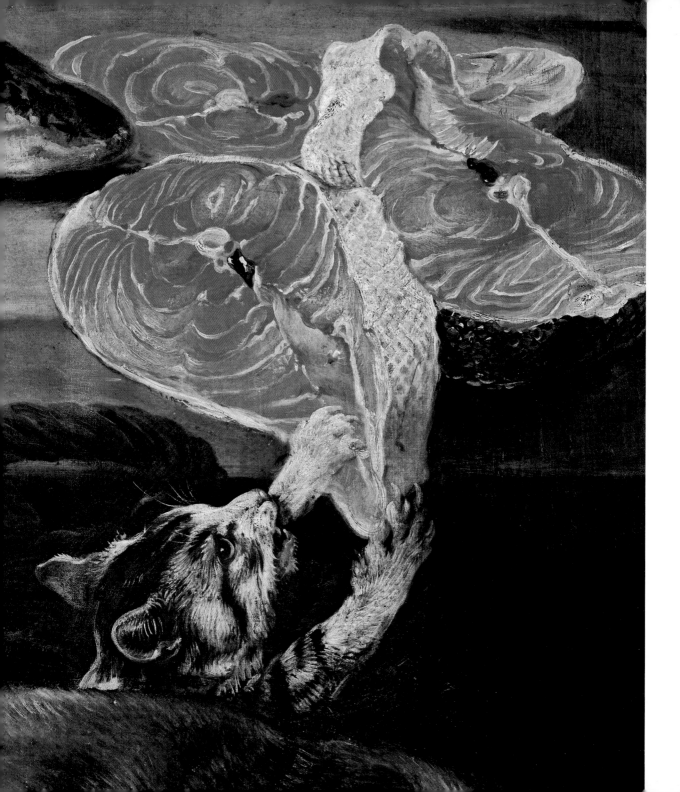

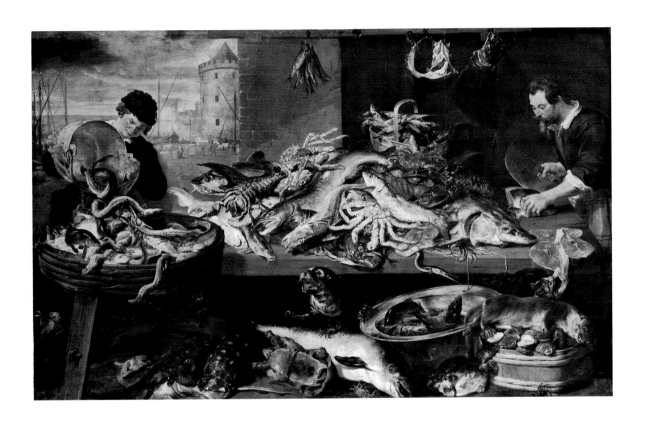

*This fish stall offers an abundance of the gifts of the sea.
While the owner is dealing with the fresh catch, a clawed
paw extends from beneath the table and the cat makes off
with a choice titbit.*

Fish Stall
Frans Snyders
Flanders. Between 1618 and 1621

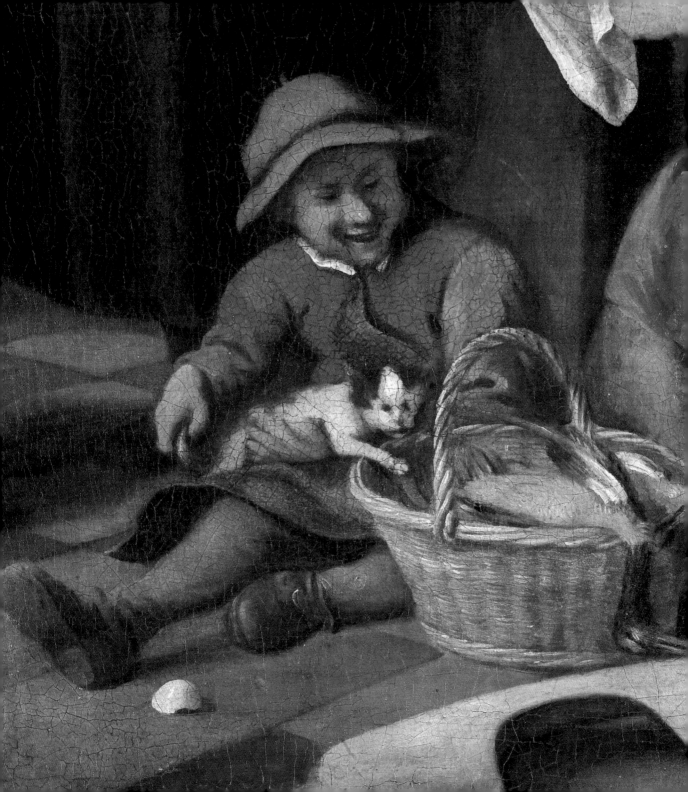

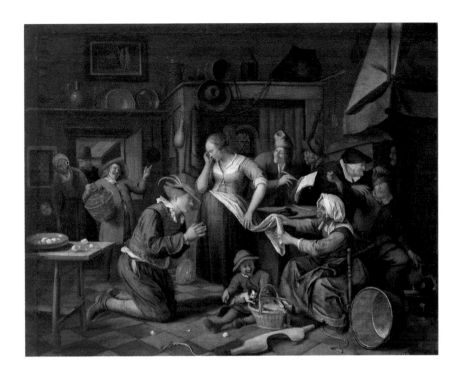

Household scenes in Western European painting are not as simple as they may seem at first glance. In this picture, a pregnant girl is being given away in marriage, and the presence of a kitten has a deeper meaning that would have been obvious to any viewer at the time. The cat symbolized the secret influence of evil forces, and the artist hinted that the devil had been at his tricks again and the girl had yielded to temptation.

The Marriage Contract
Jan Steen
Holland. Early 1650s

This family's regard for the elderly is testified to by the cat sitting comfortably under Grandmother's chair. A cat always knows who the most important person in the house is!

A Visit to Grandmother
Louis Le Nain
France. Between 1645 and 1648

The dark years of the Middle Ages passed and so did the moral condemnation and persecution of cats. Their position improved and their presence was once again tolerated in and around the home. Love for the cat as a pet increased, and Europeans gradually came to consider cats, as we do today, the guardians of the domestic hearth.

At long last, people recognized cats' exceptional intelligence and intuition and learned to respect their freedom-loving ways.

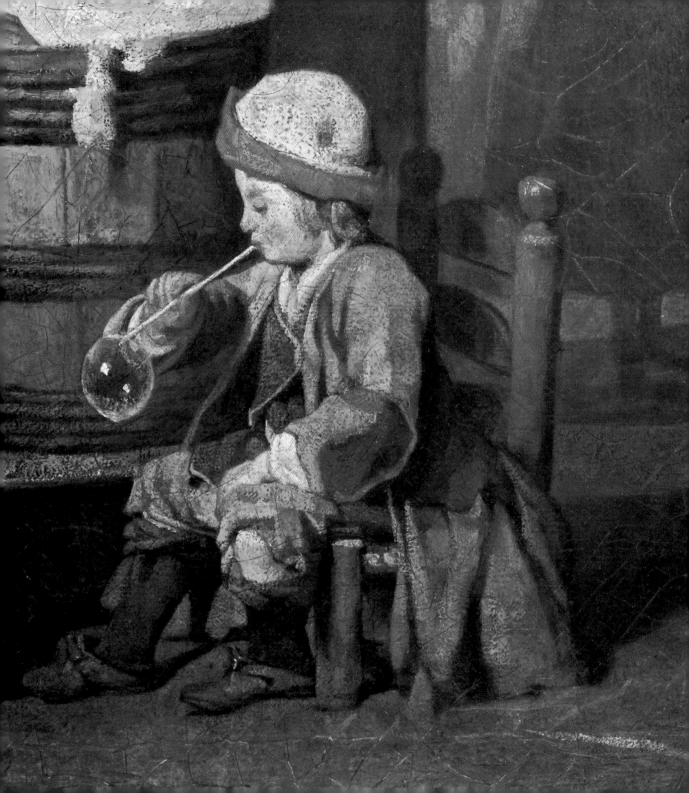

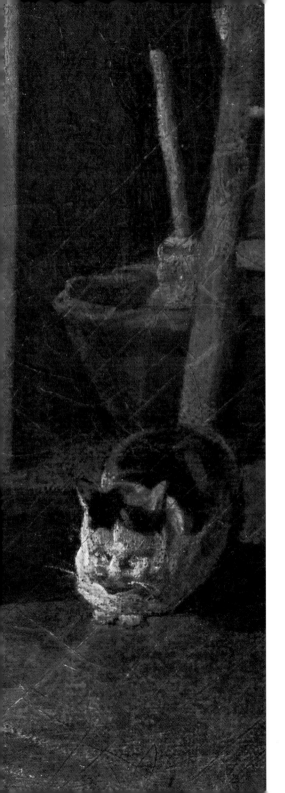

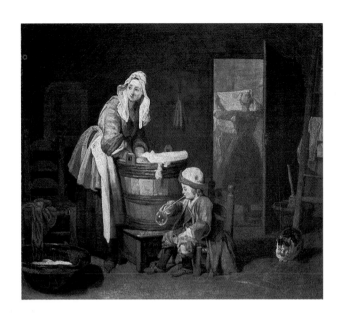

Jean-Baptiste Siméon Chardin painted his works in the Age of Enlightenment, when the gloomy Middle Ages were already a thing of the past.
He depicted daily life where everything was organized in simple and rational ways. In this domestic scene a boy is blowing soap bubbles, while the most ordinary cat is dozing near by.
There is no place for witchcraft or supernatural forces in this readily understandable and reliable world.

The Laundress
Jean-Baptiste Siméon Chardin
France. 1730s

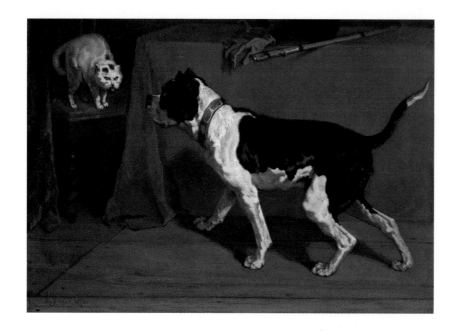

Enemies
Joseph Stevens
Belgium. 1854

The Bird Has Flown
Ferdinand de Braekeleer
Belgium. 1849

The bird has escaped from the cage and regained its freedom. And where there's a bird, there's a cat. To save the bird's life, the cat's freedom has to be restricted with a firm hug.

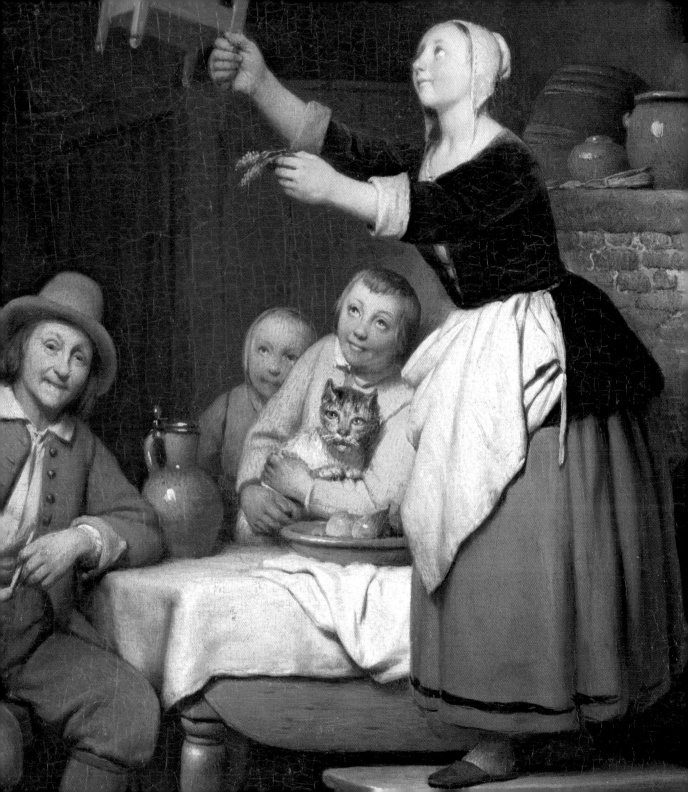

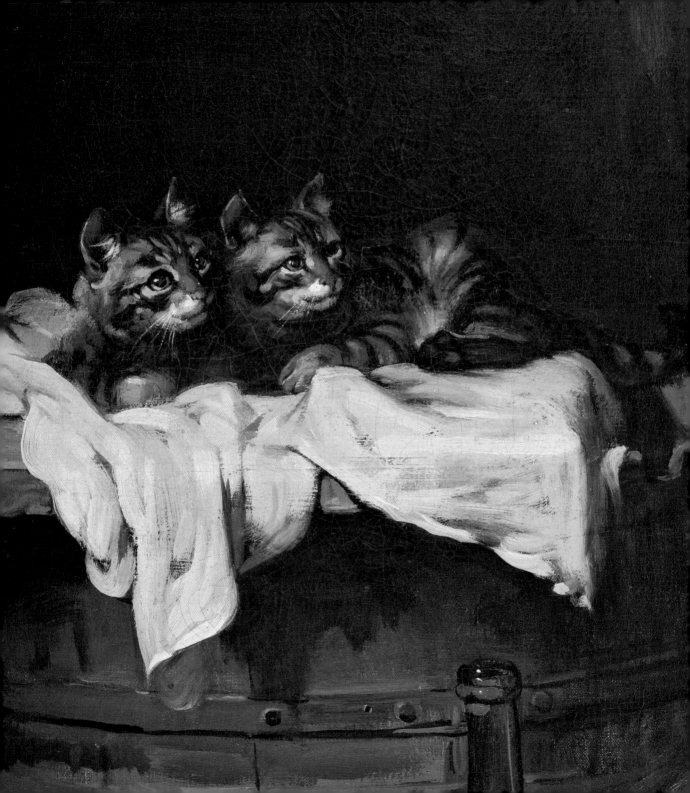

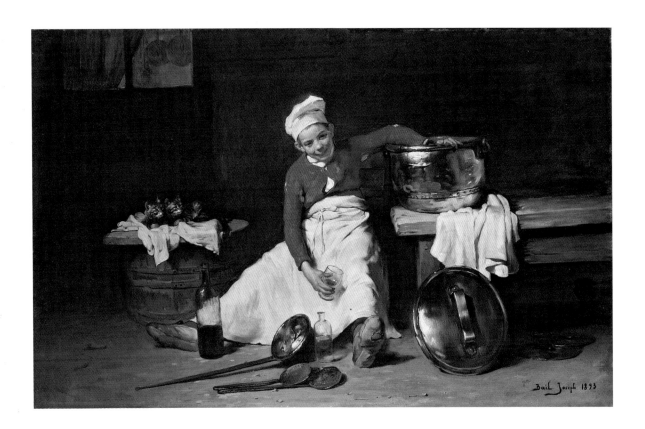

Kitchen Boy
Joseph Bail
France. 1893

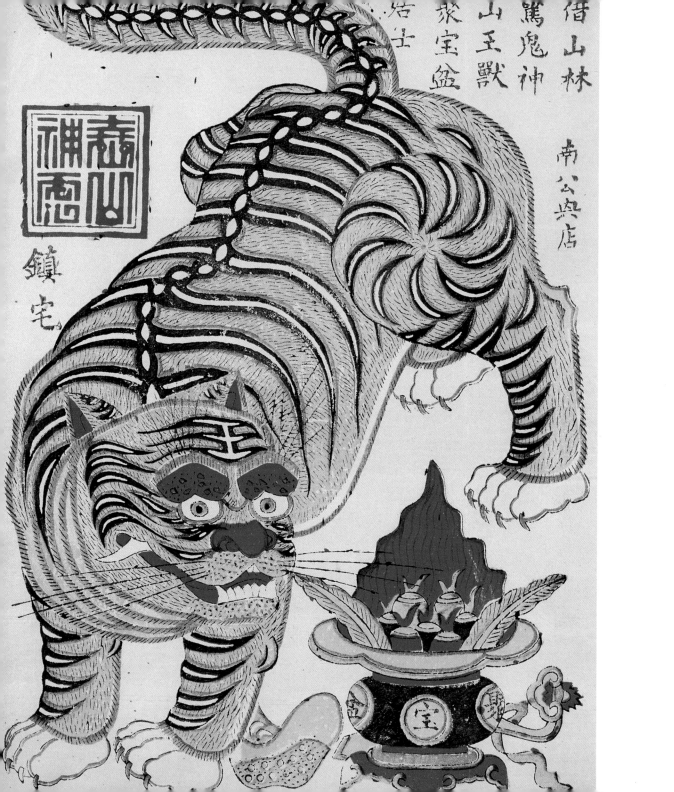

CHINA: heirs of the sacred tigers

Cats found their way to China in time immemorial. How exactly, historians have still to determine, but an old legend runs as follows.

The sacred tiger Hu had since olden times protected the grain fields from all sorts of mishaps, including the ever-present rodents. It was no easy task for him: he was heavy, and the mice were quick and nimble, scattering at his approach and making it impossible to catch them. One day a little mouse slipped from beneath Hu's paw, and its tail accidentally got into the sacred tiger's nose. The great beast sneezed and a much smaller creature sprang from his left nostril. This was the sacred cat Mao, from which, according to the legend, all others are descended.

From that moment Hu and Mao began guarding the fields together, dividing their responsibilities: the cat hunted rodents, the tiger voracious wild boars.

In order to protect their grain stores from ubiquitous mice, the diplomatic Chinese employed different tactics, ranging from intimidation (live cats) and magic (special protective pictures, like the one on the opposite page), to placation of the rodents.

The Chinese exchange New-Year gifts of pictures like this (known as nianhua*). They are a way of wishing friends and relatives all manner of blessings – health, a long life, a successful career, the birth of sons – as well as offering reliable protection. The tiger depicted here guards the welfare of the home (symbolized by a special "vessel of accumulated valuables") from evil spirits and harmful rodents.*

◄
The Sacred Tiger Protecting a House
China. Late 19th – early 20th centuries. Detail of a hanging scroll

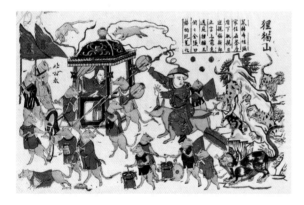

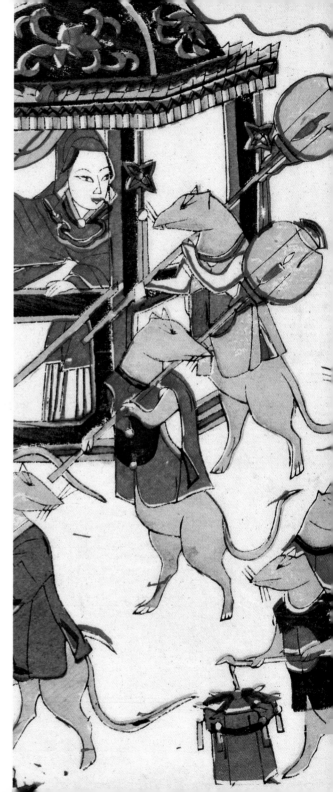

Smart mice with little lamps and musical instruments surround a bride in a palanquin and a groom riding on a mouse. But danger awaits the jolly wedding procession: the cat king and his army of fierce spotted cats suddenly spring out from behind the hills, and the startled mice scatter in all directions.

The Cat Hills
China. Late 19th – early 20th centuries

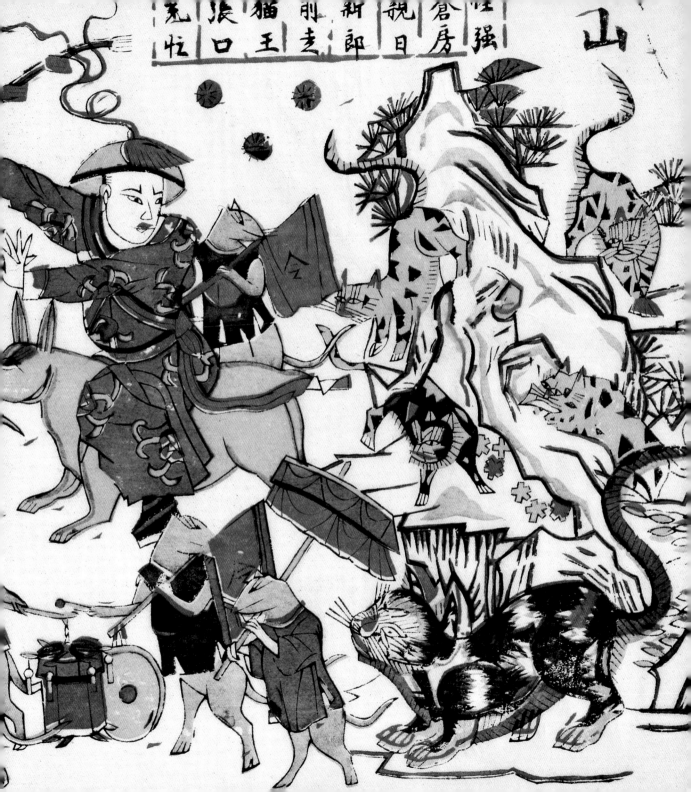

The Chinese calendar contains two days, or rather nights, that are devoted to mouse weddings. They are the 17th and 18th days of the first month of each new year. According to popular belief, on that evening you should place treats outside the mouse holes and then put out the light and go to bed earlier than usual, so as not to disturb the mice's festive supper.

In China and Japan, incidentally, the mouse as a symbol of wealth was even depicted on paper money. This is logical enough – you do not find mice in a poor home without any stocks of food.

China is a big country, and in its different parts attitudes to the feline race varied. In some places people were afraid to keep white cats because they were supposed to attract moonlight at night and become hosts for evil spirits. While Russian mothers trying to get their restless children off to sleep would usually sing them a lullaby about the grey wolf who is coming to get them, Chinese mothers would threaten their uncooperative offspring with a completely different beast: "Go to sleep or the white cat will carry you away!"

In certain other parts of China the locals were on the contrary convinced that cats were able to undo evil spells.

►
Cat
Xu Beihung
China. 1933.
Detail

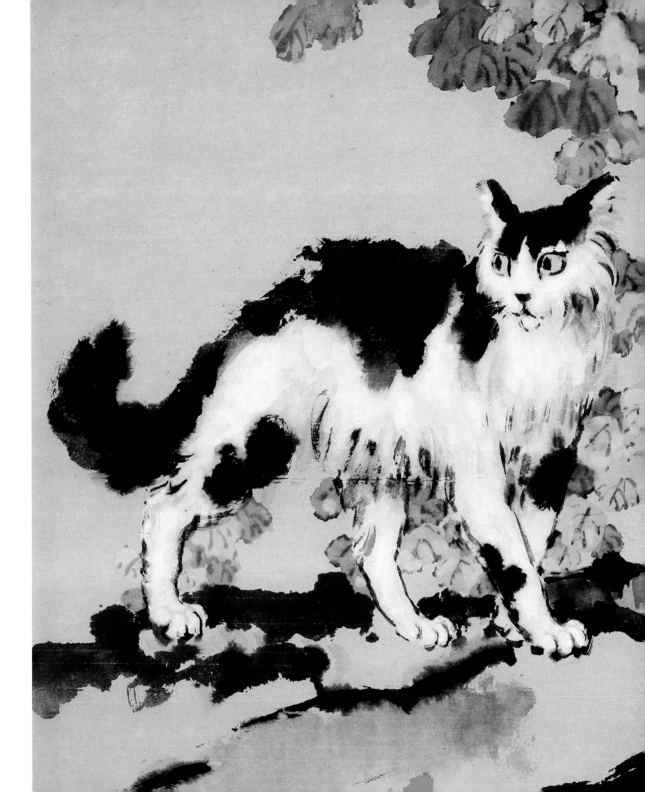

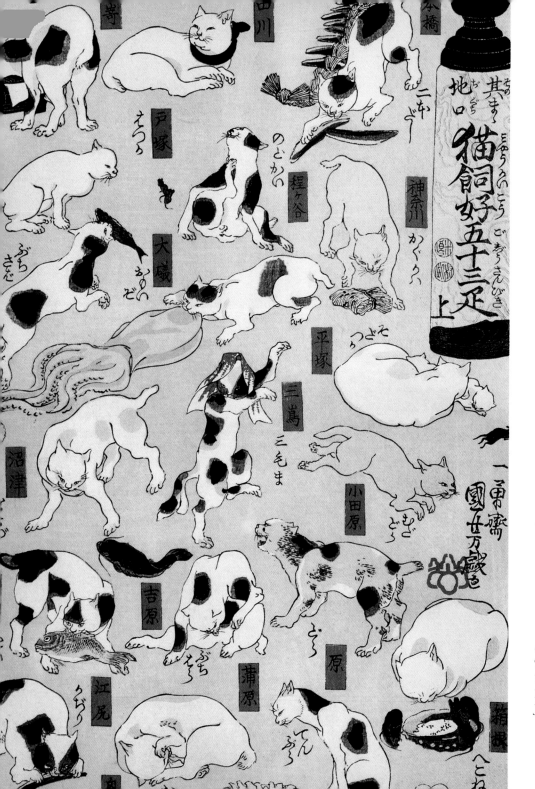

Cats Meeting on the Tokaido Road
Utagawa Kuniyoshi
Parts of a triptych
Japan. About 1845

JAPAN: for merchants and samurai

In the sixth century cats reached Japan from China. The historical legend says that they were a gift to the Japanese Emperor from the Chinese Emperor. A special minister was made responsible for the newcomers and his duties included constant vigilant care for their well-being.

The Japanese have always been fond of orderliness. Those who lived at the imperial court were invariably allotted one of eight ranks. The rank determined their sustenance and the honours that were due to them.

Cats were treasured possessions amongst the nobility. One Sei Shonagon, an eleventh-century noble lady, records in her memoirs that one particularly beloved palace cat was bestowed the rank of fifth grade of court. And Emperor Ichijo went even further when he elevated five newborn kittens to the rank of princes.

Naturally creatures of such exalted status had no official duties and did not stoop to catching mice. A cat was primarily an object for admiration – not only in the palace, but also in the homes of rich samurai and aristocrats. Cats were, however, kept on a leash, so that they wouldn't run away.

Until the early seventeenth century Japanese mice and rats felt completely at ease. They stole beans and rice with impunity, raided the stocks of flour and starch, gnawed paper parasols and left the marks of their sharp teeth everywhere – even on old monastic books and sacred Buddhist scrolls. And the cats, whose movements were restricted, could do nothing to interfere: the little pests simply kept out of their reach.

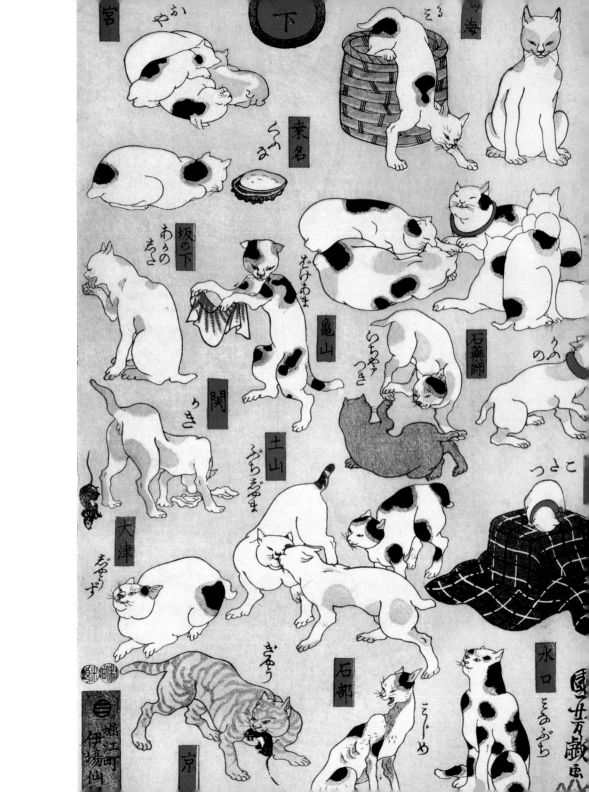

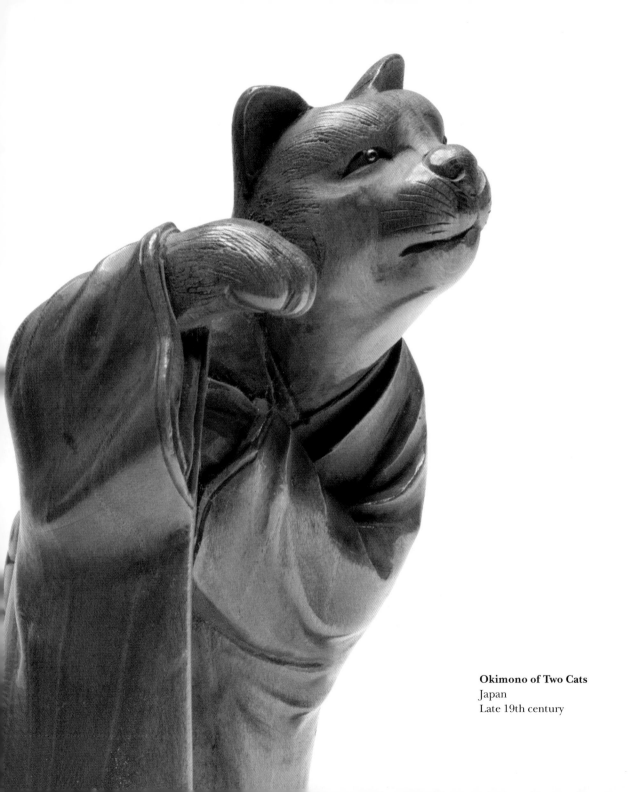

Okimono of Two Cats
Japan
Late 19th century

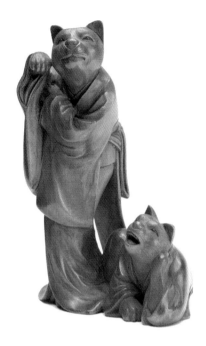

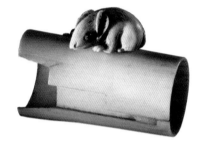

The Japanese have several popular tales regarding the origin of Japan's most famous cat Maneki Neko *(the "winking" or "beckoning" cat). One of them runs as follows. A very poor woman had a cat that she loved dearly. Once she said to her, "Sad though it is, we shall have to part. I have nothing more to feed you with." That night the cat appeared to her in a dream and said, "Don't despair. Make a clay model of me and sell it. It will bring you luck." In the morning the woman did as she was told. A rich man passing by noticed the statuette and offered her a good price for it. The delighted woman made another clay statuette, then more − and all of them were readily bought by passers-by. Thus with the help of her pet the woman escaped poverty.*
The little cat with a raised paw is supposed to invite wealth and bring good luck. Figurines similar to the original one are sold today all over Japan, and you are likely to spot this lucky cat waving at you from within just about every Japanese place of business.

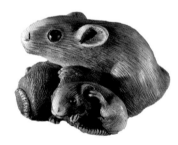

Rat on a Log Netsuke
Josui
Japan. Mid-19th century

Three Rats Netsuke
Japan
First half of the 19th century

In 1602, a decree was issued ordering the removal of cats' leashes. All the cats in the Japanese capital, Kyoto, were given a tag bearing the name of their owner and complete freedom of movement. From that moment on rats and mice had to say good-bye to their carefree life.

While paying cats due respect, the Japanese never went far enough to identify them with celestial beings, although they did believe in a link between the feline race and supernatural forces. There is an old temple in Japan dedicated to cats, and a legend tells us how it came to be there.

Once, a long, long time ago, a samurai was fleeing his enemies through the narrow streets of Edo. His pursuers, armed with swords, were closing on him. Ahead lay a dead end with nowhere else to run. At that moment the fugitive noticed a cat's paw beckoning to him from around a corner. The samurai followed this silent call and discovered a narrow passageway that saved his life. In gratitude he later founded a temple on that spot.

The temple still exists today. It includes a sanctuary and a cats' cemetery, just like in Ancient Egypt.

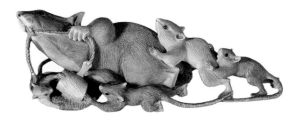

Okimono of Mice
Japan
Late 19th century

In Japan people believed that the cats' magical powers were concentrated at the tips of their tails. Not wishing to deprive themselves of feline company, in order to ensure their safety once and for all, the Japanese bred a special bobtail variety of cat.
The artist, known to have been a great cat-lover, depicted a very typical Japanese cat, but of an unusual, even frightening size.

Jinzaburo, a Samurai's Servant
Ichiyusai Kuniyoshi
From the *Lives of Loyal and Devoted Vassals*
Japan. 1847–48. Detail

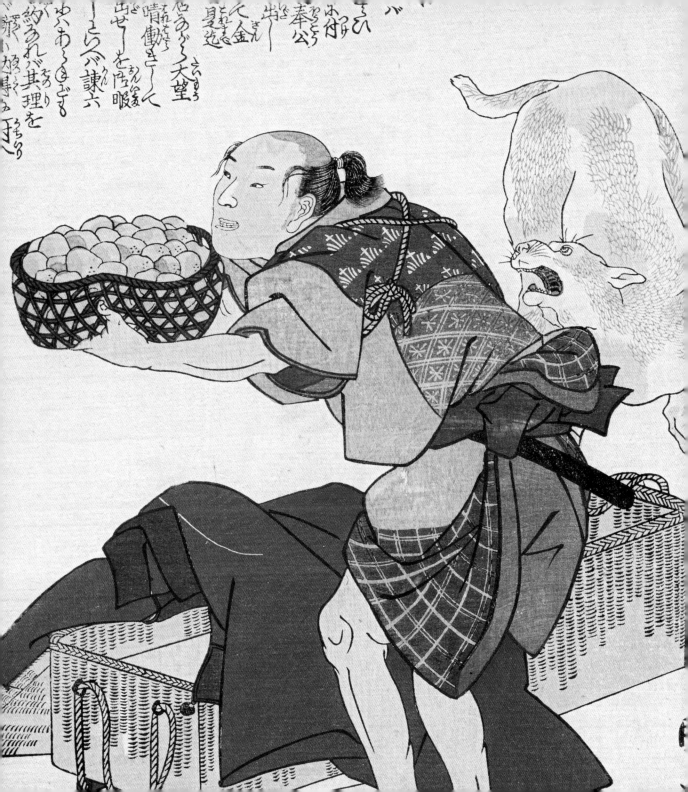

きうり

ひやうばん

バ

たうふ

おちつき

付

奉公

の人

出

人金

忠し

見返

色のくろく天堂

晴働きさ

ん六く

出せしを店暇

ちらバ諫六

かあるまず

釣るれば其理を

娘を

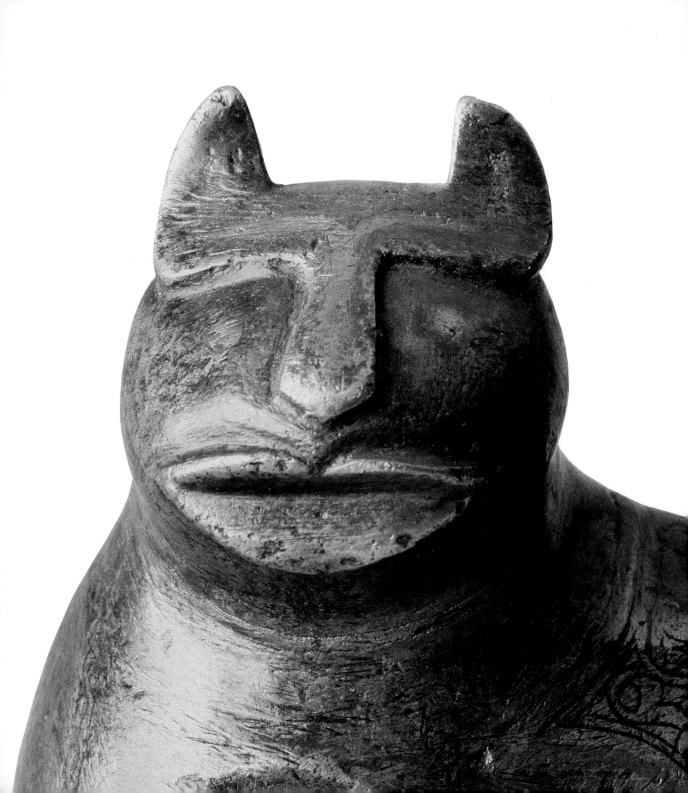

IRAN: children of the Prophet

In Iran – and in the Muslim East generally – cats were considered exceptional creatures. The Prophet Muhammad himself allotted cats a permanent place in the Muslim paradise and he it was, according to legend, who taught them to fall on all four feet. For that reason Muslims sometimes speak of the Prophet as "the Father of Cats".

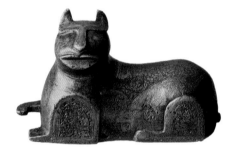

Cat
Iran. 12th – early 13th centuries

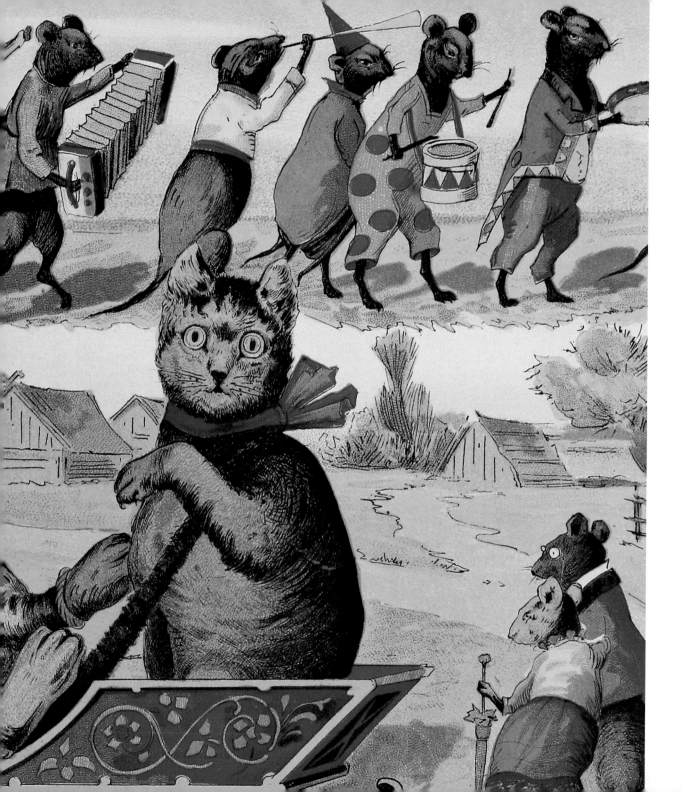

RUSSIA: guardians of the cradle

Cats settled in Russia fairly late. The first mention of them in the chronicles dates from the thirteenth century, and for the next two hundred years cats remained an exotic, outlandish wonder. The theft of a cat was punishable by a fine four times greater than that for a milch cow.

Cats were treasured so highly because they were brought from afar, most probably, as scholars claim, from the Greek colonies on the northern Black Sea coast. But an old Slav legend gives a different account of their appearance in Early Rus'.

Long, long ago the Slavonic pagan god Veles, protector of all domestic animals and cattle, went wandering on the earth. Once he spent the night in a haystack. In the morning he found he had nothing to break his fast with. Mice had eaten the chunk of bread he had been saving. The infuriated god grabbed a mouse and put it into his mitten – and the mitten turned into a cat and went off chasing the other mice. That was the beginning of cats in Russia. As time went on, cats became common in poor peasant

In the seventeenth century the type of primitive print known as lubok *appeared in Russia. Such pictures were very popular with the common people.*
The album entitled Inexpensive Popular Prints, *of very impressive size and with a large number of bright colour lithographs, was given by Emperor Nicholas II to his son, Tsarevich Alexei, for the boy's personal library as is indicated by the bookplate on the flyleaf.*
Among the many historical and literary subjects in the album was an illustration to a fable about a cat and mice.

How the Mice Buried the Cat
Lubok (popular print)
Russia. Early 20th century

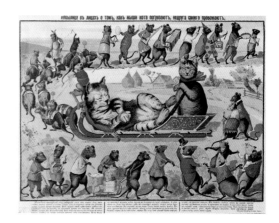

cottages, in rich merchants' houses and in boyar mansions, and effectively protected them from mice and rats.

Cats occupy an important place in Russian folk tales. As in real life, they vary in character: they are daring, cunning, inventive, and sometimes even scary. Some could sing songs and tell tales, such as the Wise Cat that the great Russian poet Alexander Pushkin placed beneath an oak on the seashore, at the entrance to a land of magic. There were, however, also cats that bewitched listeners and lulled them to sleep with their stories, then slashed them to pieces with their sharp claws.

The age-old conflict between cats and mice is also reflected in Russian folklore. There are several versions of the story of "how the mice buried the cat". In one of them, a cat pretended to be dead in order to get the mice to come closer. The mice, delighted to be rid of their enemy at last, decided they should bury him promptly to make sure. They all gathered together, tipped him onto a sled, harnessed themselves to it and dragged him off to his funeral. The tom lay there, chuckling to himself. The mice failed to notice his deceit. And when the cat did spring up and put his claws to work, it was too late.

Another story has no trickery in it. The cat did indeed die – of greed after gulping down too many mice. The rodents, overjoyed to have seen the last of him, gave him a fine funeral to merry music.

Subjects in which the small and weak at least occasionally triumph over the great and powerful often occur in Russian folk art and were fairly common in lubok *prints.*

Lubok prints were woodcuts carved by folk craftsmen on boards of lime or elm wood. Later, in the nineteenth century, they were also engraved on copper plates. In either case the prints were made on paper and coloured by hand. Often this task was entrusted to young village artists. It is not surprising, then, that the paints on these pictures were not always applied accurately, but they make up for that with their childishly naïve charm.

The prints depicted historical and folk-tale characters or religious, literary and satirical subjects. Each was usually accompanied by a lengthy inscription in vivid, memorable language. Such pictures might be pored over for a long time and even read like a book. *Lubok* prints were sold in the capital and at fairs in the remote provinces. They were reasonably cheap and extremely popular with both children and adults.

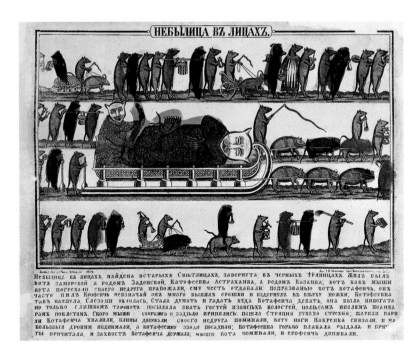

How the Mice Buried the Cat
Lubok (popular print)
Russia. 1872

Russian cats were not subject to the persecution their brothers and sisters suffered in mediaeval Europe. They were always loved and looked upon as members of the family. This attitude is reflected in popular beliefs associated with cats.

When Russians moved into a new house, they first let a cat go in, so that peace and prosperity might reign in the family home. Tortoise-shell cats were considered especially lucky. The bed would be put in the part of the room where the cat chose to lie down. If someone killed a cat, even accidentally, it meant he would have ill luck for seven years.

Tomcats were the commonest characters in Russian lullabies. Traditionally they were entrusted with lulling infants to sleep and watching over them as they slept.

A lot of superstitions connected with cats are still in use. Cats are believed to forecast the weather. Cold weather is coming if a cat sleeps rolled into a ball, and warm weather if it sleeps stretched out. If a cat washes itself, you are sure to have visitors.

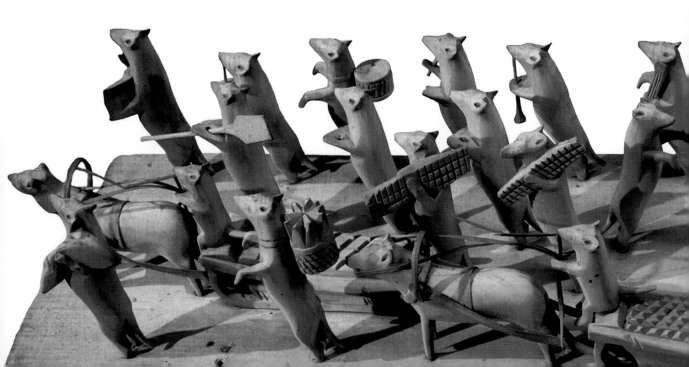

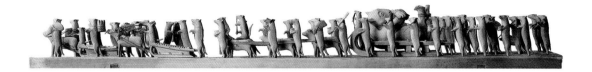

How the Mice Buried the Cat
Bogorodskoye wooden toy
Russia. Early 20th century

Surviving examples of toys like this can be counted on the fingers of one hand. The craftsmen from the village of Bogorodskoye very rarely created such elaborate pieces. This procession was clearly made to commission – not for sheer amusement, but to be examined at length and admired. It contains over sixty figures, none the same. Each mouse is carrying something different: a musical instrument, a broom, a spade, a firkin... And the expressions on their little faces are varied too.

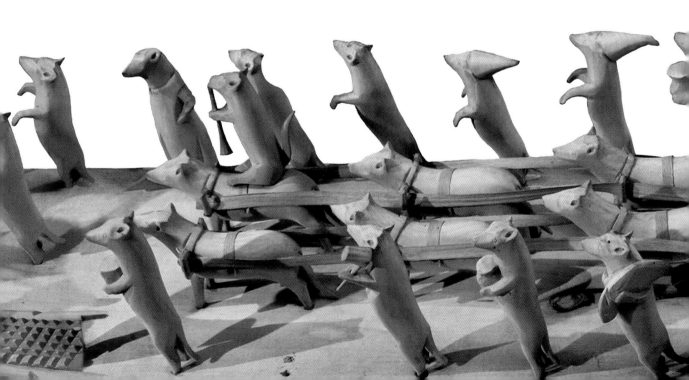

Black cats, though, are a very different matter. A black cat crossing your path is a bad portent. When friends fall out, people say that a black cat must have run between them. Expect no luck from a black cat!

The subject of mice burying their enemy the cat occurs not only in *lubok* prints, but in other forms of folk art as well. Such tales also inspired the makers of the popular Bogorodskoye toys.

The village of Bogorodskoye, not far from Moscow, was famous from the late sixteenth century for its folk craftsmen who skilfully carved wooden toys with moving parts. Push a rod one way, then the other, and amusing rabbits beat a drum, or a smith and a bear take turns to strike an anvil, or a clown swivels between poles. The toys were usually carved from soft limewood (sometimes painted) and sold at fairs. Less often the toymakers worked to commissions, producing elaborate many-figure compositions, such as the cat's funeral.

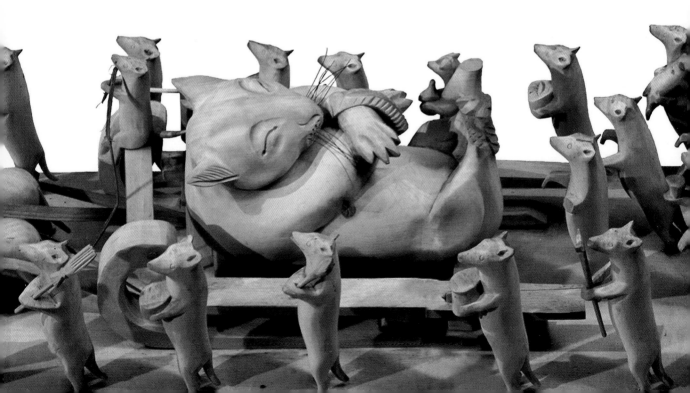

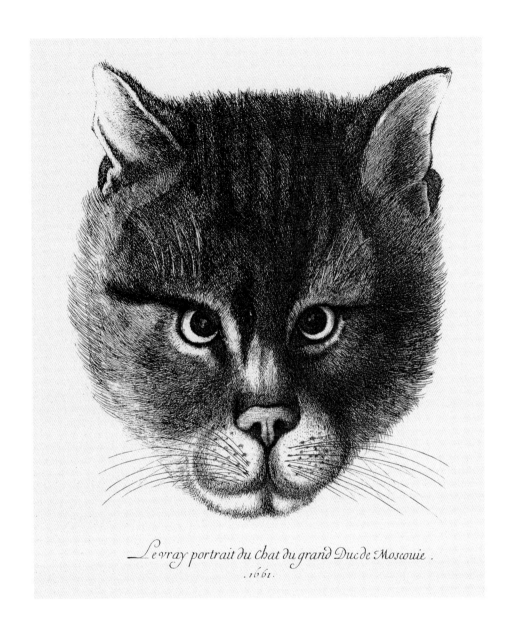

Le vray portrait du chat du grand Duc de Moscouie.
.1661.

**"The True Portrait of the Cat of
the Grand Duke of Muscovy"**
(Tsar Alexei Mikhailovich)
Frédéric Moucheron. Holland. 1661

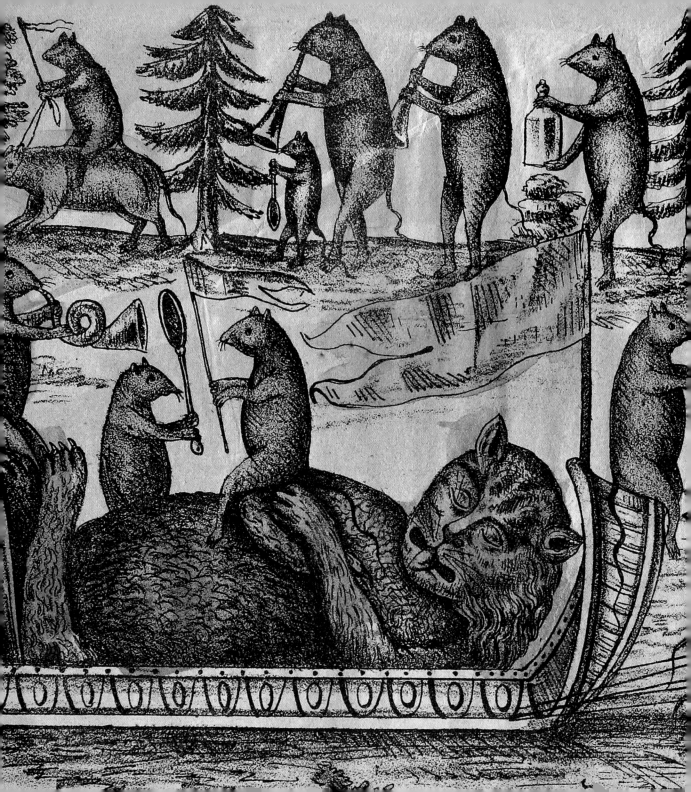

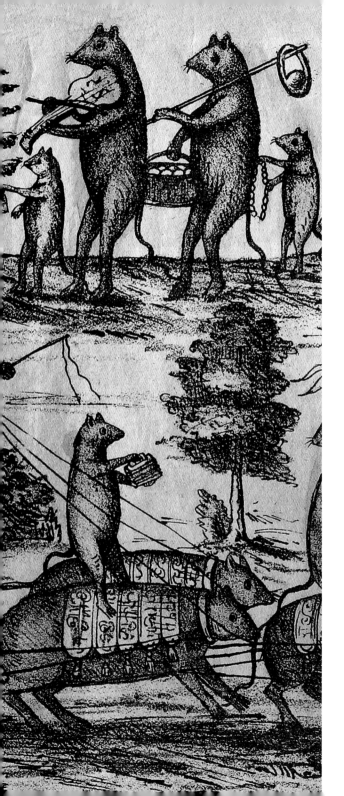

This lubok, *like the majority of such prints, carries an explanatory inscription. It tells us that there was once a Siberian tom of prodigious size with great whiskers "like a Turk's". He was very fond of catching mice, ate them by the dozen and was never full. But one day the greedy creature overate and "died once and for all".*
The mice and rats were delighted to at last be rid of the tyrant and carried the cat to his grave with music and songs. They could now look forward to an untroubled life.

Rats and Mice Burying the Cat
Lubok (popular print)
Russia. 1879

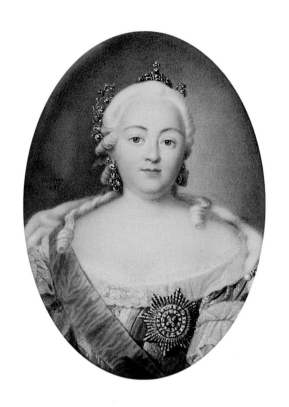

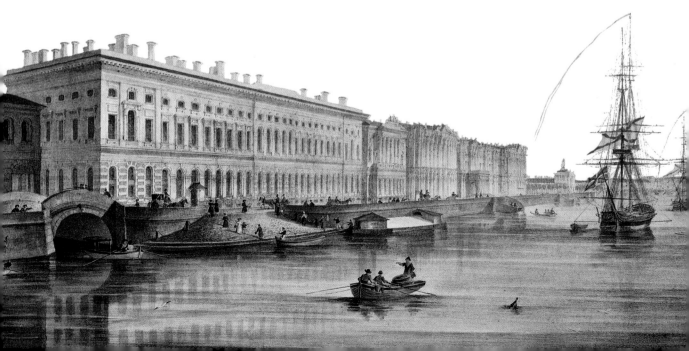

ST. PETERSBURG: cats in the palace

Not long after the start of Empress Elizabeth's reign, the Governor-General of Kazan, Artemy Zagriazhsky, received an urgent dispatch, brought by a special courier. It was dated 2 November 1745 and signed by the Empress herself:

"Seek out in Kazan thirty of the largest and finest cats and send them to St. Petersburg, to the court of Her Imperial Majesty, together with a man who could feed and take care of them. Dispatch them immediately, providing them with transport, a travelling allowance and an appropriate sum for victuals."

The Empress addressed her request to Zagriazhsky personally, because at that time Kazan was noted for its special breed of mousers. In memoirs of the period they are described as strong, active animals with large heads, muscular necks and shoulders, and short tails. It was these tough Kazan toms that Empress Elizabeth needed.

Obeying the decree, the Governor instructed that notices be posted calling for suitable animals. Owners who failed to report their cats to the Governor's office within three days were to be fined. The required number of animals were quickly found and dispatched to St. Petersburg.

◄

Portrait of Empress Elizabeth
Jean-Henri Benner
France. 1821

◄

View of Palace Embankment by the Hermitage Theatre
Karl Beggrow
Russia. 1826. Detail

This is what the imperial palace looked like from the River Neva a century after Empress Elizabeth.

The valuable cargo reached its destination safely, and the long association between cats and their new home, the Winter Palace, began.

Over the years the palace was reconstructed, enlarged and altered, while generation after generation of mousers performed their service.

At first the cats guarded only the imperial apartments from mice and rats, but with the founding of the Hermitage in 1764 (it was then that Catherine II began to acquire works of art from Western Europe) they guarded the museum's collections too.

Special rules were drawn up for the keeping of the palace cats and set down in writing. One of them reads: "Do not feed the cats mutton, to avoid them becoming obstinate in spirit and character." The animals were given nothing but small portions of veal to eat, so that they would not neglect their main duty.

In the time of Empress Catherine II the cats were divided into outdoor animals and household animals. Only a select few belonged to the second category.

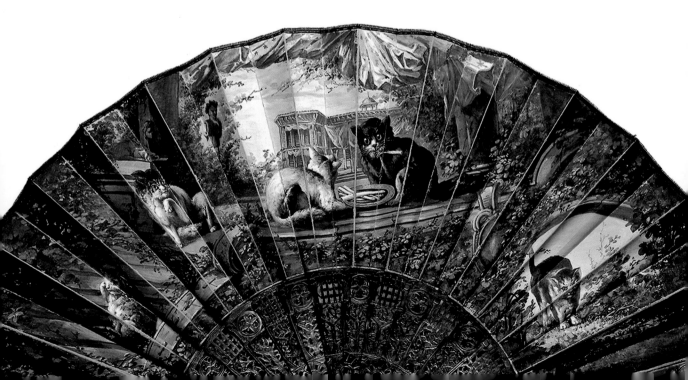

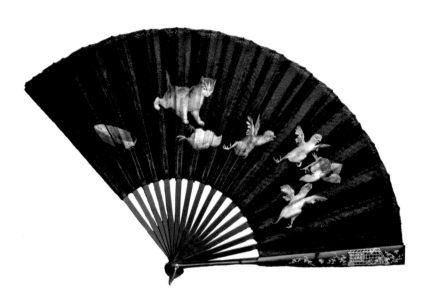

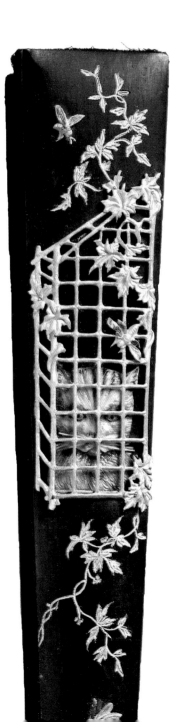

In the late nineteenth century there was a vogue for fans painted
with amusing subjects featuring animals, birds and funny little
human figures. Some of these fans were even painted personally
by members of the imperial family as gifts for relatives.

Fan owned by Princess Zinaida Yusupova
France. 1890s

*On this slat there is a depiction of a cat in a cage.
When the fan is opened out we can see why he is being punished.*

Fan owned by Tsarevna Maria Fiodorovna
(the future wife of Alexander III)
France. 1870s. Detail

*This fan carries a picture of a company of cats relaxing
in a park. Two of them are eating asparagus.*

Yelizaveta Golovina, one of Empress Catherine's maids of honour, was very fond of animals generally and of cats in particular. In her memoirs she recalled one stroll in Tsarskoye Selo, the Empress' summer residence: "Her Majesty sat down on a bench and ordered me to sit beside her. The Empress told me about her American cat, a gift from Prince Potemkin and very devoted to her." During the conversation, the animal itself put in an appearance. When Golovina picked her up, she playfully scratched the maid of honour's cheek. Catherine was very upset by this behaviour. "The poor puss," Golovina concluded, "was locked in an iron cage and sent off to the city, to the Hermitage." It served her right: a cat with a temper like that had no place in the imperial apartments.

Time went on. One monarch succeeded another on the Russian throne. In 1917 the Winter Palace ceased to be an imperial residence, but it remained a home for cats. The furry guards continued to perform their duty loyally.

They still do so today.

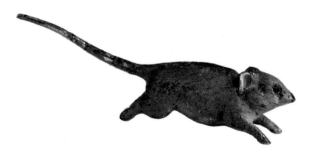

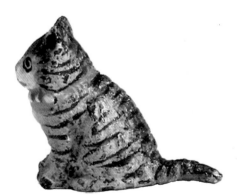

Toy Cat
Western Europe. 19th century

Toy Mouse
Western Europe. 19th century

LIST OF ILLUSTRATIONS

Nikolai Gol
Maria Haltunen

THE HERMITAGE CATS

ACKNOWLEDGEMENTS

The publishers would like to thank for their
enthusiastic assistance in selecting and describing
illustrations the following members of the
Hermitage staff:
Ekaterina Abramova
Tatyana Danilova
Leah Livshits
Maria Menshikova
Andrei Nikolayev
Kira Samosiuk
Maria Seklikova

ISBN 978-1-910065-66-2

NOTES ON THE ILLUSTRATIONS:

Alexei Bogoliubov
Anastasia Bukina
Natalia Gritsai
Galina Miroliubova
Sergei Nilov
Yulia Plotnikova
Anton Chebotarev

Translated from the Russian by Paul Williams
Designed by Olga Pen

Photography: Yury Molodkovets, Leonard Heifetz,
Valery Zubarov, Sergei Taranov
Project editor: Elena Streltsova
Translation editor: Irina Komarova
Layout: Nikolai Shandarchuk
Colour editor: Igor Bondar

Printed and bound in India by Imprint Digital Ltd

Unicorn Publishing Group LLP
66 Charlotte Street
London, UK
www.unicornpress.org

First published by
ARCA Publishers in 2007
43 Moika Embankment
St Petersburg, 191065, Russia